£5.95

Illuminated Calligraphy

c44/1

In memory of N.A.V. Romer M.B.E.
of Upminster, Essex, England
who taught me all I know about
the art of calligraphy and
book illumination

Other books by Patricia Carter
Illuminated Alphabets (in preparation)

Illuminated Calligraphy

PATRICIA CARTER

SEARCH PRESS

First published in Great Britain 1989
Search Press Limited
Wellwood, North Farm Road,
Tunbridge Wells, Kent TN2 3DR

Reprinted 1990

Calligraphy by Anne Gardner

The author would like to thank her husband Alan, her
sons David and Bruce, and their families for the many art
books they have given her; she would also like to give her
grateful thanks to Rosalind Dace for her help in editing
her manuscript.

ISBN 0 85532 642 5 (Pb)
ISBN 0 85532 675 1 (C)

Typeset by Scribe Design, Gillingham, Kent
Made and printed in Spain by A.G. Elkar, S. Coop.
48012-Bilbao.

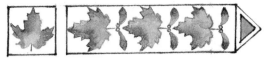
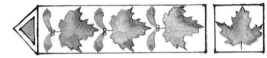

Contents

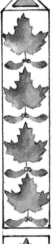
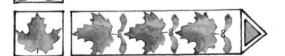

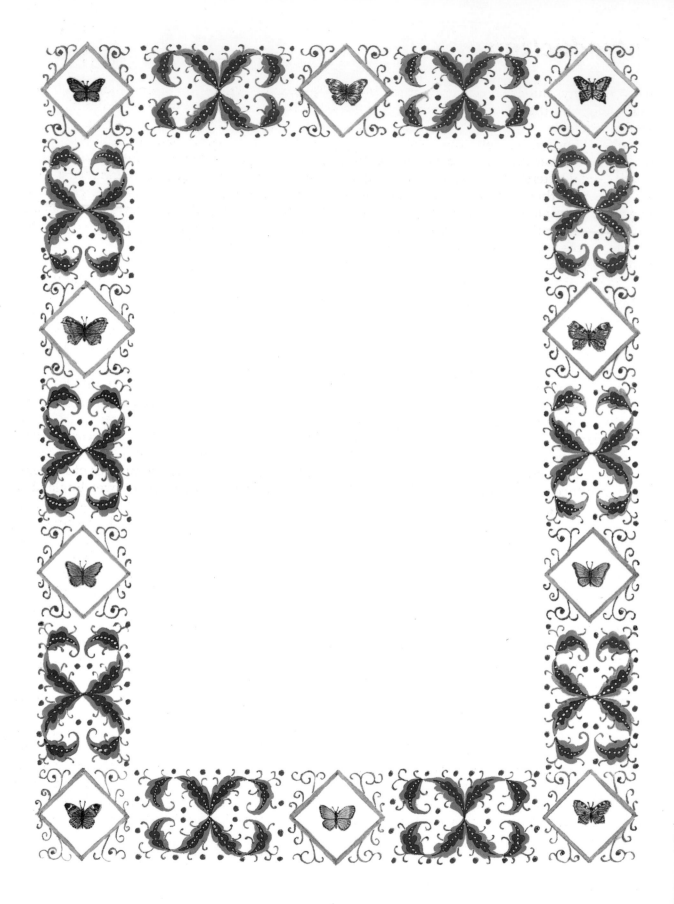

Introduction

It is not my intention to teach the art of calligraphy in these pages; there are many books available which show how to create beautiful handwritten lettering. Nor is it my intention to cover the techniques of decorating initial capital letters, although several examples are shown. Rather I show how to illuminate a page using simple and more complex borders; I illustrate how the application of colour to a simple quote or message can enhance the letterforms, transforming them into personal documents to be treasured. Hopefully the borders I have designed for this book will inspire you to investigate the art of illumination in greater depth. I only give general guidelines to help the beginner and enthusiast.

Over 30,000 years ago primitive people were painting pictures on cave walls using charcoal, stick brushes and paints made from powdered earth colours mixed with animal fat. Then followed the slow evolution of pictures into symbols, and symbols into letters. As alphabets took shape, beautiful works of art were produced, combining letterforms with pictures and designs.

The word 'illumination' as it suggests is the decoration of a page, letter, etc., by the application of colour, gold or silver. Throughout history images have been used to decorate and reinforce the written word. Many of the mediaeval manuscripts that can be seen today still retain their vibrant colour, the ancient texts embellished with glorious detail. The Book of Kells is one of the most splendid manuscripts of the Middle Ages. The beauty of this ancient Irish volume has fascinated generations of historians and artists throughout the centuries.

Scribes and illuminators created these manuscripts in conditions that could be described as primitive by today's standards. Candles offered poor light as scribes laboured away for long hours, hunched over dimly lit desks in cold, draughty rooms. Tools were hand-made.

Texts were written on animal skins with quill and reed pens; paints were created out of plant and mineral pigments which were ground into powder form; gums had to be added to the powdered colour before paints were applied; gold was frequently added to enhance a page. Some of the traditional tools and materials used by these mediaeval scribes are not available today, but it is possible to obtain substitutes which produce good results.

The birth of the printing press in the mid-fifteenth century heralded a fall in the usefulness of handwritten books and manuscripts. It wasn't until the end of the eighteenth century that there was a revival of interest in England with the work of William Blake, and later on William Morris.

My own interest in calligraphy and illumination began quite by chance. I was commissioned by a professional calligrapher to write and illuminate a piece of work, after he had seen my miniature paintings. I have never looked back. I now write a number of Remembrance books for churches all over England. I also write one for Norwich Cathedral. It is a skill that is both enjoyable and rewarding.

The borders in this book need not solely be used to illuminate calligraphy. They can be modified or elaborated and used for many crafts including embroidery, wood carving, pottery, stone masonry, or stained glass work. The applications are too numerous to mention. Artists too will find inspiration in the delicate friezes, flowers and garlands that decorate these pages.

Everyone has their own idea of beauty. What appeals to one person will not appeal to another, but I hope the borders I use in this book will help you create your own designs. Once the basic techniques have been mastered they can be used as a springboard for your own ideas, and you will be able to produce beautiful, harmonious illuminated texts to treasure.

Materials

The range of materials required is not extensive, nor is it too costly; but if you are a beginner it is an idea to buy only the basics until you have had time to practice and decide on your preferences. Most art shops or stationers stock a good range of equipment and once you have invested in your basic materials they should, with care, last for a long time. It will only be necessary to replenish used supplies of paint, ink, gold leaf and paper.

Work surface

You do not need a very large working area and although it is possible to work on a flat surface, it is easier and less tiring to use a slanting surface. Beginners could make their own angled work surface on a table top by propping up a board against a book or pile of books. A medium-sized stout piece of plywood can be used. Obviously if you are working on larger designs, then you will need a larger board. Whatever size you use, make sure that the board rests securely on the table. A single involuntary movement could spoil hours of careful work!

Small desk top drawing boards are available from most art suppliers. Some have parallel rules attached, which are useful when ruling lines on a page and most can be adjusted to whatever angle is required. An ideal angle is 45°, which enables you to see how your work is progressing, but if this is uncomfortable choose the angle that suits you best.

If you find your work surface is too hard, or is not smooth enough, it will be necessary to lay down some backing material before commencing work – several sheets of blotting paper would be ideal. It is also a good idea to

position an extra piece of paper under your 'working' hand, to protect your work from grease and smudging.

Paper

There is a seemingly endless variety of paper available to suit every medium, ranging from rough to smooth. The best paper is hand-made but this is expensive and I would recommend a beginner to experiment first with a good quality smooth-surfaced cartridge paper.

I prefer to use a line and wash paper – or occasionally line and wash board if I am intending to frame a piece of work. If you use board you do not have to mount your work before framing it. For all the borders in this book I have used an acid free cartridge paper, 150 gsm (70 lb).

I always keep plenty of inexpensive copy paper which I use when planning my designs. Tracing paper is essential for planning a layout and for transferring the chosen design on to the final sheet of paper or vellum.

Vellum

Vellum is the traditional surface for calligraphers and illuminators. It is carefully prepared out of calf, sheep or kid skin and it is much more expensive than paper. If you are intending to design a border for a special person or occasion, it is well worth paying extra.

I do not cover the techniques of painting on

vellum in this book. There are other books available which explain them in much greater detail. It is important to familiarise yourself with these techniques before attempting your first masterpiece!

Parchment

Parchment is prepared out of sheep skin. It is possible to buy it nowadays, but it is much more delicate than vellum – although less expensive. There are also some very good imitation parchments available now which are much cheaper. I use parchment occasionally for some works, but it is difficult to remove mistakes from its smooth, slippery surface.

Pencils

Pencils are graded according to softness and hardness – the 'H' range being the hardest and the 'B' range being the softest, with HB falling between the two. An 'F' grade is also available. This does not smudge as much as the 'B' grades and is darker than an HB. In the 'H' range the higher the number the harder the lead. In the 'B' range the higher the number the softer the lead. I always use hard pencils, checking they are sharp before I start work.

I use the '2H' and '2B' when tracing designs, the '3B' for transferring designs and the '2B' when working on vellum. It is advisable to use pencils no softer than this if you intend working on vellum, as soft lead smudges easily and it is almost impossible to remove the smudges without damaging the surface.

Erasers

There are many types of erasers available. Coloured rubbers could stain the surface of the paper, so I use a soft white rubber for removing pencil marks. If you want to erase marks on vellum be very careful, as the surface can easily be damaged, and pencil marks can smudge and smear. Use a hard rubber gum or soft rubber to remove any unwanted lines.

Pens

Scroll pens, double-pointed pens, reed, quill and steel-nibbed pens can all be used to create colourful, decorative borders. It is worthwhile experimenting with these and other pens once you have mastered the basic techniques in this book. I frequently use a very fine, high quality technical pen for delicate and detailed work. A mapping pen can also be used for fine details.

Inks

There are some lovely, brilliantly coloured inks available today. However, they are not really satisfactory for illumination as they tend to fade. If you want your work to be lasting it is better to use paints.

When drawing fine details with my mapping pen, I use black Indian ink.

Paints

Watercolours are sold in pans, cakes or tubes. Cake and pan colours have to be moistened with the brush and rubbed to release the colour. Tube colours are convenient to use and can be mixed more easily. I use watercolours for very fine detailed work; they are an essential part of my palette when painting the miniatures I use to decorate my borders.

Gouache is also sold in pans, cakes or tubes. The cake colours need to be diluted with a moist brush; tube colours are ready for immediate use. Over-mixing can produce dull colours, so where possible it is better to keep mixing to a minimum. I use gouache for embellishing capital letters and for less detailed work.

Acrylics may be mixed with water, or they can be used straight from the tube, but unlike watercolour which becomes lighter in tone, on drying they become darker. If you decide to use acrylics remember to make due allowance for this.

Ready ground powdered colours can be used. They are pure and strong and resemble the paints used by mediaeval scribes and artists. These colours have to be mixed with gum or egg, so they adhere to the painting surface. I would not advise beginners to use these paints because the colours are difficult to prepare.

Brushes

I find good quality sable brushes are best for my work. It is advisable to spend as much as you can afford on a small selection. If they are well cared for they will last for several years. Sizes 000–4 are ideal for the detailed work in my borders; larger areas of colour can be created by using larger brushes.

Ox hair and squirrel brushes are cheaper and usable, but they do not last as long as sable brushes and they loose their points sooner. It is best to buy the sable if you possibly can.

Wash your brushes thoroughly after use and shape the tips. Always protect the tips. A small tube made out of thick paper, which is dropped over the head of the brush and secured with tape, offers adequate protection.

Other materials

Special materials are needed for applying gold leaf and these are listed in the section on gilding, (see page 18).

Geometrical equipment is always useful. A ruler showing both metric and imperial measurements is necessary for ruling up lines, and I often have need of a set square, T-square and compasses or templates when designing the more difficult borders. I find it better when drawing circles with a compass, to make a template on a separate piece of paper. This is to avoid damaging the surface of the paper or vellum I am working on with the compass point; or you can simply use a stencil.

A sharp knife with a good quality blade, (a craft knife is ideal), is required for sharpening pencils and also another sharp bladed knife is needed for scraping off any ink errors – make sure the ink is dry before removing your mistakes.

A palette is necessary for mixing paints, or you can improvise by using clean white saucers or plates. Blotting paper and clean rags are useful for cleaning equipment after use.

Design

Design forms an essential part of calligraphy and illumination. Whether interpreting the words of a chosen quotation or piece of text, or whether decorating a name or initial, the calligrapher and artist should aim to create a design that is both harmonious and pleasing to the eye.

I have brought together a whole range of designs in these pages aimed to inspire both the beginner and the more advanced student. The spaces on a page are as important as the decorations themselves. They play an integral part in the overall feeling of harmony and balance. The composition of spaces, lettering and decoration must have an underlying rhythm.

When choosing a border design I always ensure that the subject matter will complement the style of calligraphy. For example, I usually choose a nature theme when working with Gothic or Foundational Hand. I like the way delicate tendrils, flower heads and leaves, or miniature paintings of small animals and tiny insects complement the lines and curves of the script. I always stylise the designs I use with Gothic lettering, in keeping with the age and style of the script, but when using Foundational Hand, with its rounded letters, my designs are more natural and free-flowing.

It is worthwhile visiting museums, libraries and colleges to see the works of ancient scribes and to look at historical documents and manuscripts. By studying the illuminated texts, colours and decorations, ideas will form for your own designs. It is also a matter of preference as to how much decoration you include. The simple application of one colour to an initial letter can enhance a page of calligraphy, although handwritten lettering with no adornment can look just as pleasing. You can choose dainty filigrees, simple gold borders or rich tapestries of colour which fill the page. Using nature, history, art, architecture and literature as inspiration you can adapt and interpret the ideas and designs you see.

Colour

The use of colour is a personal thing. No-one can advise when or where to use a certain shade. It is entirely up to the individual. I find it is better not to introduce too many colours into a design, or the overall effect becomes muddled, and I always repeat any colours I use in a design at least twice which gives a balance and rhythm to the border.

The quotation or text you choose to illuminate may conjure up images of vivid reds and swirls of gold, or it may bring to mind beautiful sunny yellows and cool blues. Don't be afraid to experiment with these colours – lay them down side by side on a piece of scrap paper; hold the paper at arms length and if the colours do not complement one another try again, painting a different range on a separate piece of paper. It is important to experiment until you achieve a range of colours that blend well together and produce a feeling of harmony and balance.

Choosing your paints

There is a wonderful range of paints and colours available today. It is frequently bewildering for the beginner to be confronted with such a variety. I prefer to use watercolours, because I find they are best suited to my more delicately detailed borders, although mistakes are almost impossible to rectify.

I also use gouache. When applied straight from the tube these paints are very thick and have to be diluted for fine work. It is an ideal medium for decorating initial letters or for filling in flat areas of colour round a border, but some of the colours lose their brilliance when mixed and they can become muddy in appearance. Gouache has the advantage of being opaque and therefore mistakes can easily be painted over.

Acrylics may be used, but they dry very quickly. They also need to be diluted for use; if they are used too thickly the overall effect is too heavy. Delicate work requires a delicate approach.

Powdered colours too can be used and a suitable binding agent has to be added before use. These paints give the purest colours.

Whatever paints you choose, it is a matter of personal taste, and only with practice will you discover your preference.

Choosing your palette

Good artists' materials suppliers stock a comprehensive range of colour charts and it is worthwhile studying these before making any decisions. A basic range of colours is all that is required. A reliable palette consists of a selection of yellows, reds and blues, plus a few auxiliary colours. I use the following: yellow ochre, cadmium yellow, vermilion, violet alizarin, ultramarine, viridian (or alizarin green), lamp black and Chinese white.

Mixing your colours

The primary colours are red, yellow and blue. These can be mixed and diluted to produce a wide range of other colours. When you have organised your basic palette, experiment with the primary hues; using the colour wheel below as a guide, mix the colours together: yellow mixed with red will produce orange; red mixed with blue will produce violet; blue mixed with yellow will produce green.

When mixing up your colours, always mix more than you need. If you run out of the mixture before your design is finished, it is almost impossible to match up the colour exactly.

The colours shown in the colour wheel and my basic palette form the basis of all my colour work. It is possible to mix or buy other colours and add them to your palette. It is all a matter of personal taste.

Colour chart

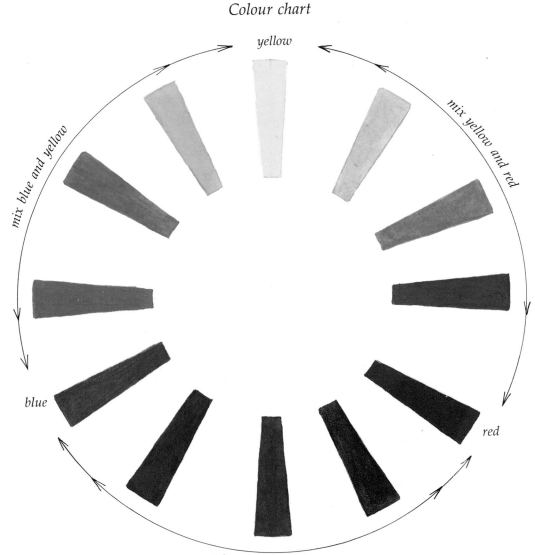

Techniques

Here I discuss the basic techniques required to create simple colour decoration. Experiment and practice with the many different borders in this book. It is only by copying ideas and trying out the techniques that you will eventually be able to create your own designs.

Planning your design

Although I do not teach the techniques of calligraphy in this book, I feel it is necessary to cover a few basic points when discussing the overall design of a page. The handwritten text is an integral part of the border and has to be considered in the initial design stage. The whole design has to be harmonious and pleasing to the eye.

First of all choose your text, then decide on the size and shape of your layout, remembering that margins and spacing play their part in the design. The choice of lettering is also important and should suit the subject matter of the text; the size and shape of the letters will affect the amount of space left for decoration. At this early stage I always make a rough draft and pencil a preliminary design on paper; working out the amount of space the text will take up.

Initial letters

Although I do not show many decorated initials in this book, there are several illustrated and it is worthwhile remembering a few basic rules.

The style of the initial should complement or be the same as your handwritten text, and the letter should be legible. The placing of the initial is important as it forms an integral part of the design and the spacing is important. Plan your rough carefully, (see opposite).

I always choose decorations that harmonise with the border design; flowers, leaves, ribbons, dots, scrolls, insects, animals or birds can be cleverly and carefully intertwined around the curves and lines of initials.

Choosing your design

Once the calligraphy has been chosen, think about the border design, the size and the colour. You could begin by decorating the initial letter, or trying very simple corner designs. Experiment with simple linear or geometric borders, delicate floral designs, banners or ribbons. A few ideas are illustrated opposite. Experiment on your rough draft until you are happy with the result.

Transferring the design

Occasionally I paint or draw straight on to the final surface, but if you are unsure it is better to use the tracing paper method below.
1. Once you have finalised your design and carefully worked out the exact measurements, rule up your page and write out your chosen text on your paper or vellum.

Now you are ready to transfer the border design on to the final surface using your rough draft as reference.
2. Trace off the design from your rough layout using a clean sheet of tracing paper and a fairly hard pencil. Make sure the design is accurate by placing it in position over the calligraphy. I make any adjustments at this stage, rubbing out mistakes and re-drawing lines.
3. Turn the tracing paper over; position it on a rough piece of paper and carefully go over the lines of the design on the back with a soft 'B' pencil – I prefer to use a '2B'.
4. Accurately replace your traced design over your calligraphy, right side up, and exerting a gentle pressure go over the outlines of the drawing with a hard pencil ('2H'), so the pattern is transferred on to your final surface. It is wise at this stage to place a clean piece of paper between the tracing paper and the final surface, where your hand is resting, to avoid smudging.

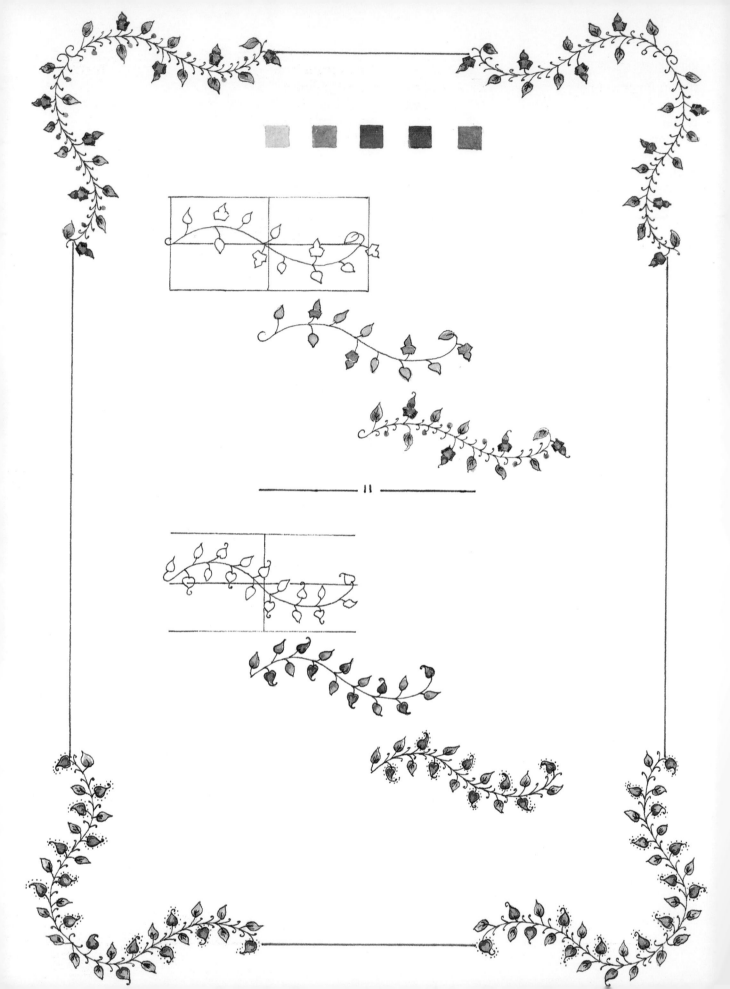

REPEAT PATTERNS

If you wish to use a repeat pattern on a corner, as in the designs opposite, use the tracing paper method. This time just use a soft pencil.

1. Mark the bottom left hand corner of your design with a cross and trace the outlines on both sides of the tracing paper.

2. With the cross showing on the top left hand corner of the pattern, transfer the design to the top left hand corner of the layout.

3. Reverse the tracing paper; position it along the left side of the layout with the cross in the top left hand corner and repeat. Use the same method on remaining corners.

The method for creating more complicated corner designs can be seen on page 57.

A design can also be repeated all round the border using this technique.

Applying colour to your design

Sometimes the addition of just one colour to black text is extremely effective. The simple application of a little red or gold can brighten up a page beautifully. It is better not to use too many colours, or the overall effect becomes too busy and muddled.

I prefer to use watercolour on delicate designs, like the one shown here. Also, as you paint on the first washes you can see how the final design is going to look. I always plan out my colours on my rough layout first, aiming to keep the whole feeling harmonious by choosing colours that will complement each other.

Make sure you have clean water available for mixing and for washing out brushes, and if you are mixing colours check that you have enough

to complete the design. It is difficult to mix exact colours more than once.

If I am outlining the design in ink, I always mark in the outline first using a technical pen, going over the traced pencil lines (these pencil lines can be erased later). Any extra adornments can be added later once the painting is complete.

In a simple border like the example below, I apply the colour in three stages and I work from the outside of the page inwards, so that my hand is not resting on the calligraphy. I work with a piece of paper under my painting hand to avoid any smudging.

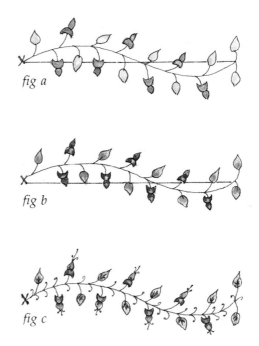

fig a

fig b

fig c

First I lay down a basic light wash, keeping the colour within the outlines of the pattern (see fig. a); after this initial wash I add any shading that is required (see fig. b); finally I ink in extra adornments or features, such as tendrils and leaf veins (see fig. c). The same basic rules can apply to almost any simple design.

If you decide not to use ink on outlines, any remaining visible pencil lines can be erased once the paint has dried thoroughly. This must be done carefully or you may rub out some of the colour.

Gilding

There are a variety of gold pens, inks and paints available, but these tend to tarnish and darken in time. I use them on my rough layout when planning the colours. Or they can be used on greetings cards, invitations and small items that will not be kept for any length of time.

Shell gold is used with distilled water and is more permanent. It can be made up using real gold powder, or it can be bought ready prepared, but it is fairly expensive. The making up process is fiddly and I recommend buying the ready prepared solution, which was originally sold in small shells – hence its name. It is now available in small pans, or in tablet form. I use shell gold occasionally on my borders as it is ideal for small dots of gold, or for fine delicate work. If the shell gold is too runny, it tends to spread into other colours. It can be thickened up by adding a small amount of gum arabic. I always apply it after my other colours because of its tendency to run. Once it is dry it can be burnished. Inks, paints and shell gold can all be applied using a fine sable brush. The brush used for shell gold should be kept solely for this purpose.

I prefer to use gold leaf, although the techniques of application are a little more involved. The lovely finish of gold leaf makes the extra effort worthwhile. It is cheaper than shell gold and can be bought from most good art suppliers.

Guidelines for applying gold leaf

It is advisable to practice applying gold leaf on an odd piece of paper first, before attempting the technique on your finished design, as it is not an easy process to master.

If I am creating a design with just a page of handwritten calligraphy and one decorated initial, I always apply the gold first. When illuminating a decorated page, I prefer to leave the application of gold leaf as the final stage. Either way, be careful not to disturb or touch the gold once it is in position. Any handling, accidental or otherwise, will cause a dulling of the surface. Always work from the outside in towards the centre of the design and position a piece of paper under your hand and over the completed design to avoid smudging and as protection.

MATERIALS

Fine sable brush
Water matt gold size (or gesso)
Book of gold leaf
A pair of small sharp scissors
Tweezers
Thin paper
Sharp craft knife
Soft paint brush
Agate burnisher

I use size or gesso when applying gold leaf. It is sold in small pans resembling blocks of paint. It forms a sticky surface upon which the gold is laid.

Water is added before the size or gesso is applied; the resulting mixture should be of a fairly thin consistency – thin enough to be applied evenly over the surface of the paper. Keep the size or gesso clean after it has been

applied or the gold leaf will not adhere to its surface.

Gold leaf can either be bought in small packs containing a few leaves or large books containing many leaves.

There are several types and shapes of burnishers available in various sizes; these are used to burnish the gold.

METHOD

1. Gold leaf must be applied on a flat, clean and hard surface. A slanting surface could cause the size to run down and form puddles at the base of the design.
2. Make sure all your materials are at hand and readily accessible and draw out your design.

3. Mix the size, or gesso, with water and brush it evenly on to the paper or vellum. If tiny bubbles appear, pop them with a needle or pin. The surface of the size or gesso should be left to dry out until it is slightly damp and sticky to the touch; so that it forms a suitable surface for the gold leaf. If you are intending to gild several areas, apply the gesso or size for all areas at this stage.

4. When the surface of the size or gesso is ready, cut a piece of gold leaf, with clean, sharp scissors, a little larger than is required. This is to ensure that the whole area to be gilded will be covered. Cut through the backing paper and the gold leaf, holding the cut out piece with tweezers. Try to avoid touching the gold leaf, as greasy hands can dull the surface.

5. As the gesso or size needs to be fairly moist and sticky, breathe on it a few times to prepare the surface. Taking care not to damage the gold leaf, gently press it face down on to the size or gesso, with the backing paper still in position. Hold the paper firmly.
6. Place a piece of thin paper over the backing paper, pressing down lightly with your fingertips. Use the tip of the burnisher to transfer the gold on to the design. Rub the burnisher tip over the whole design surface and all edges as smoothly and as quickly as possible.

7. Remove the backing paper and top 'rubbing' paper and gently brush away any stray pieces of gold with a soft brush which is kept solely for this purpose.

8. Any ragged edges of gold can be tidied up by scraping them off carefully with a sharp craft knife.

9. It is advisable to burnish the gold when the size is dry, so wait for at least fifteen minutes before commencing. Make sure your burnisher is completely clean, or it may damage the surface of the gold.

Using light, circular movements rub the burnisher over the gold until it starts to feel smooth, then move the burnisher in straight lines across the gold to achieve a lovely bright polish.

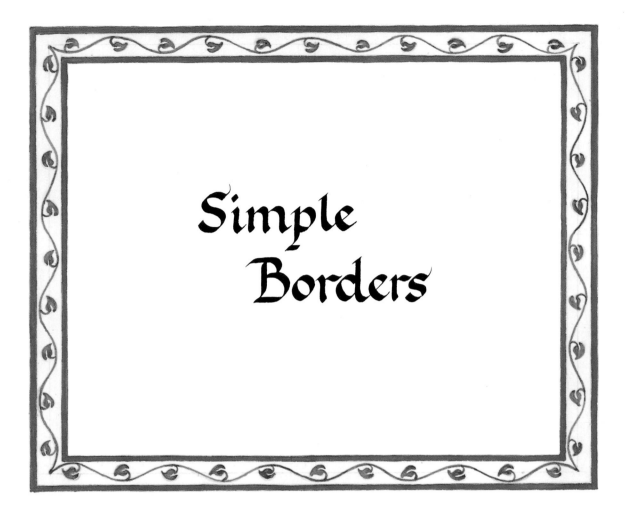

Leaf border

Purple lines form a pleasing framework for a light wash and a simple leaf pattern. The techniques required for the borders in this and the following sections can be found on pages 11–20.

Harlequin border

A lovely stained glass window effect is simply achieved with a limited palette by using colours in a geometric pattern. The centre panels and inner border resemble wrought iron work, the curves contrasting well with the lines and angles of the main design. After drawing out the design in pencil, I apply the colours in sequence, painting one colour at a time around the whole border. Lighter and darker shades of the same colour are also painted in.

When all the colours have been applied, and the paint is dry, I outline each section with a technical pen, and ink in the side panels and inner border. Finally I erase any remaining pencil marks.

Arrowhead border

Using North American Indian arrowheads as inspiration, I have designed this simple border using several contrasting colours over a very pale, light wash. I apply the colours one at a time, around the border, working from light to dark, leaving the corner sections until last. When the colours are dry, I draw in the surrounding black lines, using a technical pen and ruler, and erase any visible pencil lines.

A slight variation in the pattern and colours can be used to create different borders. Here the basic wash is the same, but the main pattern colours and shape of the arrowheads have been altered. The bordering black lines have also been changed.

24

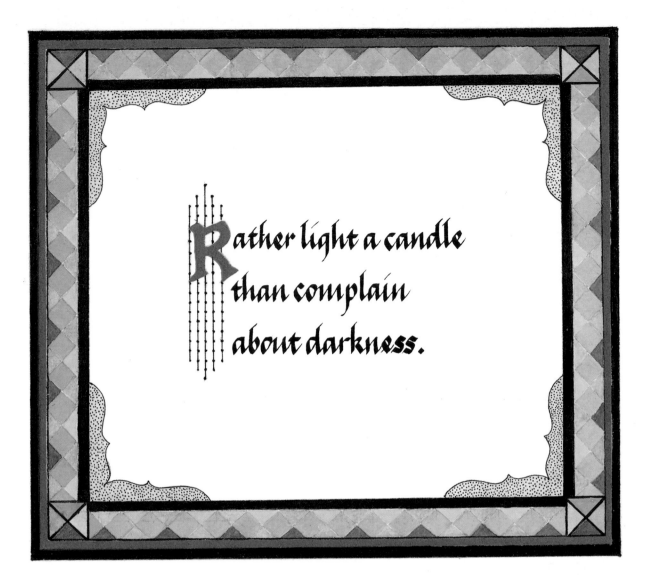

Rather light a candle than complain about darkness.

◁ *Eastern border*

The same colours are used to create three very different designs. I often play around with different ideas and colours on pieces of scrap paper, and the large surrounding border is a result of one of these 'doodles', which is based on an Eastern design. The pattern is built up round the inner border, the corners of which resemble brackets. After applying the colours and when the whole border is dry, I draw in the black lines and dots with a technical pen.

The inner design on the right is shown above and the design on the left shows how lines and curves can be combined to create a pleasing pattern.

Diamond border △

A three dimensional effect can be created by heavily outlining a border in a contrasting colour. This simple diamond design is based on a series of crosses, using the 'brackets' idea to accentuate corners (see opposite). After applying the colours and allowing them to dry, I draw in the black lines and dots with a technical pen and erase any remaining pencil lines.

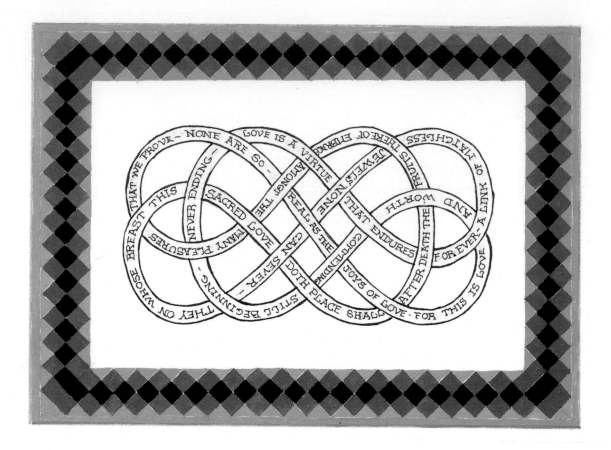

Lovers' knot

Using the same idea for design as the previous page, and the same techniques, a different range of colours is used inside a simple frame. The swirls and curves of the lovers' knot contrast well with the straight lines of the border.

Maple leaf border

A single repeating maple leaf inset in a series of panels forms the basis of this pretty design. Before applying the colours, experiment on a spare piece of paper, blending one colour into another. When using colours like this, I dilute them with water and gently blend them together using a fairly large brush, keeping within the outlines of the drawing.

I paint in the triangles at the panel endings last and when the colours are dry, I draw in the lines with a technical pen and erase any remaining pencil lines.

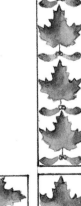
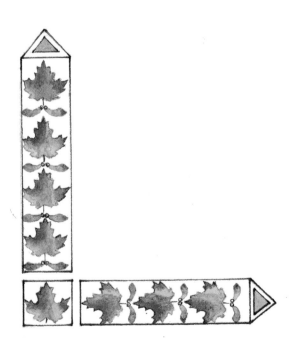
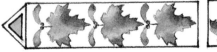

Bookmarks

Whereas watercolours have a transparent quality, gouache is more opaque when applied. Consequently, when working with coloured backgrounds I prefer to use gouache. Here I illustrate how simple borders can transform bookmarks into personal gifts to treasure. There are many beautifully coloured papers and cards available, or plain bookmarks can be bought ready-made and decorations applied. A single coloured border can be just as effective as a border containing several contrasting colours.

Dots, lines and curves can be used to create interesting designs. Darker colours on lighter backgrounds are extremely effective.

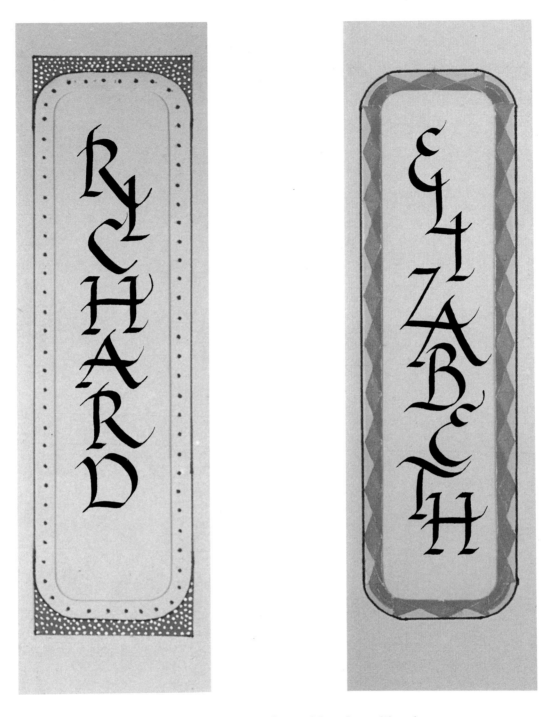

Simple two or three coloured borders, like the ones above can be used to embellish names or messages for friends and relatives.

Greetings cards

Tiny flowers and leaves can be entwined around borders and I use them frequently when designing cards for friends and relatives. I either buy ready-made cards, or I make my own from coloured paper. Paints, inks, felt-tipped pens, etc., can be used to decorate borders and messages.

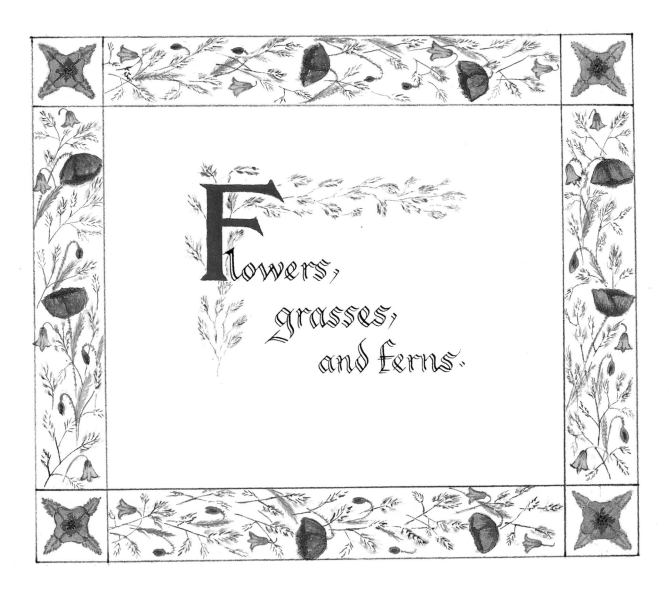

Wild flower border

I found these flowers growing at the bottom of my garden. I sketched them first, then arranged my sketches into a natural free-flowing design, using the flower heads to decorate the corners. After drawing out the design in pencil, I apply the colours one at a time in sequence, before ruling the lines in with a technical pen (when the paint is dry) and erasing any visible pencil lines.

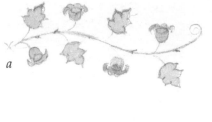

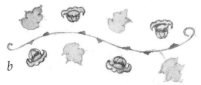

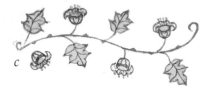

Flowers, leaves and stems

Artists and illuminators have used plants as a source of inspiration for centuries. Delicate flower heads, leaves, stems and tendrils can be entwined round any awkward gap or corner with ease. I spend time studying the plants first, and work from sketches or photographs, building up the design on my rough layout, using the method shown opposite.

Patterns a, b and c show the gradual build up of colour, shading and detail. The other designs shown on this page are created using the same techniques and they are all based on studies I have made on plants and flowers.

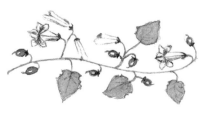

Extending your design

Opposite I show how corners can be decorated with twisting stems, leaves and flower heads, which can be extended naturally along borders. Using the designs and grid lines as shown, draw up a rough border and practice positioning the plants around corner sections and extending them to cover straight edges.

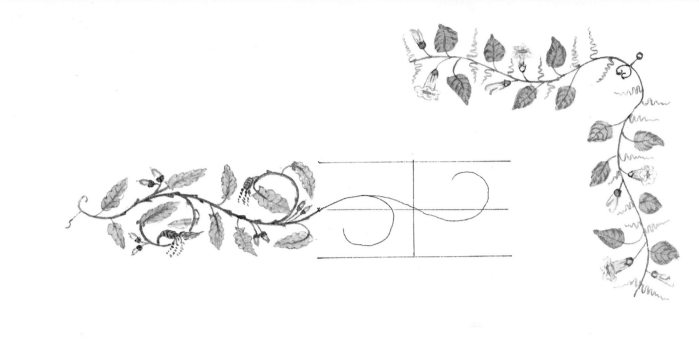

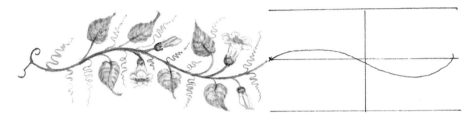

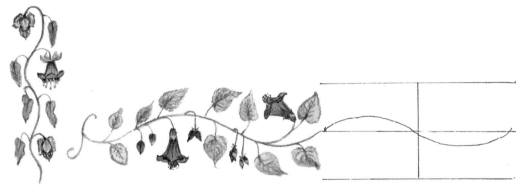

Scarlet pimpernel border

Beautiful borders can be simply created with a repeat design of delicate flowers and leaves.

After selecting my text and design, and after working out the measurements on my rough layout, I transfer them to the final surface. In the border design opposite the reds and greens are highlighted by small dots of shell gold. Finally to tighten up the design, I rule single lines between the flower patterns, using a mapping pen and red paint.

The pattern above can be used to plan your own simple design. Use the tracing paper method to build up the pattern, (see page 17).

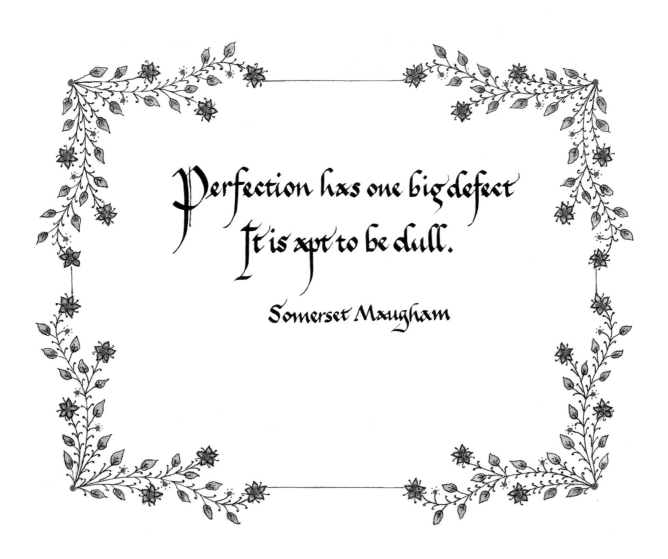

Perfection has one big defect
It is apt to be dull.

Somerset Maugham

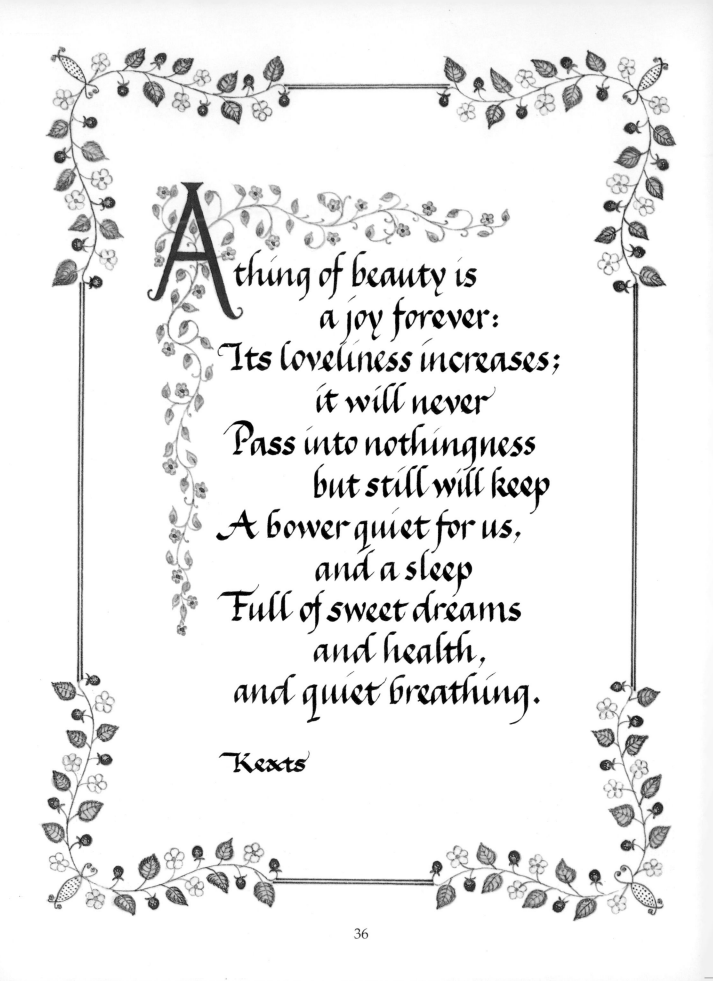

A thing of beauty is
a joy forever:
Its loveliness increases;
it will never
Pass into nothingness
but still will keep
A bower quiet for us,
and a sleep
Full of sweet dreams
and health,
and quiet breathing.

Keats

The smile that
you send out
returns to you

◁Red berry border

A repeat pattern can be used on small or large borders. After writing out the text on my final surface, I apply the design and the colours, then highlight each corner with tiny dots of shell gold. Double lines are ruled in on each side with a mapping pen and red paint to complete the border.

Bluebell border △

Tiny red berries and semi-stylised bluebell flower heads decorate stems and leaves which twist round a straight-edged border. I prefer to use a limited palette and here I use three colours on the flower pattern; these are repeated on all four corners which gives a sense of rhythm and balance to the design.

*Happy thoughts
happy hours
happy times
to cherish always*

Patricia Carter

Semi-stylised border △

Plants can be used round straight edged borders in a variety of ways. Here the flowers, tendrils and trailing stems merely touch the outer edges and corners. The delicate shades of purple, pink and green are highlighted with dots of shell gold.

Rose border ▷

Flowers can be adapted in a variety of ways. As a contrast to the semi-stylised flowers in this section, here I have designed a free-flowing pattern which can be lengthened or shortened, as desired. The design is not the same on each side, but the colours are carefully balanced to give a harmonious feeling.

After writing out the text and decorating the initial letter, I apply watercolour to the inside rose pattern, then paint in the bordering branches in gouache.

Man cannot for a
thousand days
on end enjoy
the good,
just as the flower
cannot bloom
a hundred days.

TSENG·KUANG

Stylised vine borders

These borders are based on a series of circles, with the vines weaving over and under the basic pattern. Larger stylised open flower heads can be used to decorate corners and extended into the design. One colour used throughout can be as effective as several different colours; use circles to build up your own patterns, using the designs below as a guide.

I use a compass, or templates, to draw the circles which form the basis of my design.

Here I use a mapping pen and red paint to create a delicate single-coloured design.

A pretty design is created using a limited palette.

Enclosed borders

Plants and flowers can be enclosed and surrounded with either gold or black lines and pale background washes added to enhance the design. These three repeat patterns are the same width, but I have treated them all differently.

In all these examples I apply the wash first, then the colours in sequence. Finally, the black lines are drawn in with a technical pen. ·

· This is a stylised grapevine pattern based on small circles, with a central theme.

This design is again based on the grapevine but the circular pattern is larger and uninterrupted.

An ivy plant gave me the inspiration for this design.

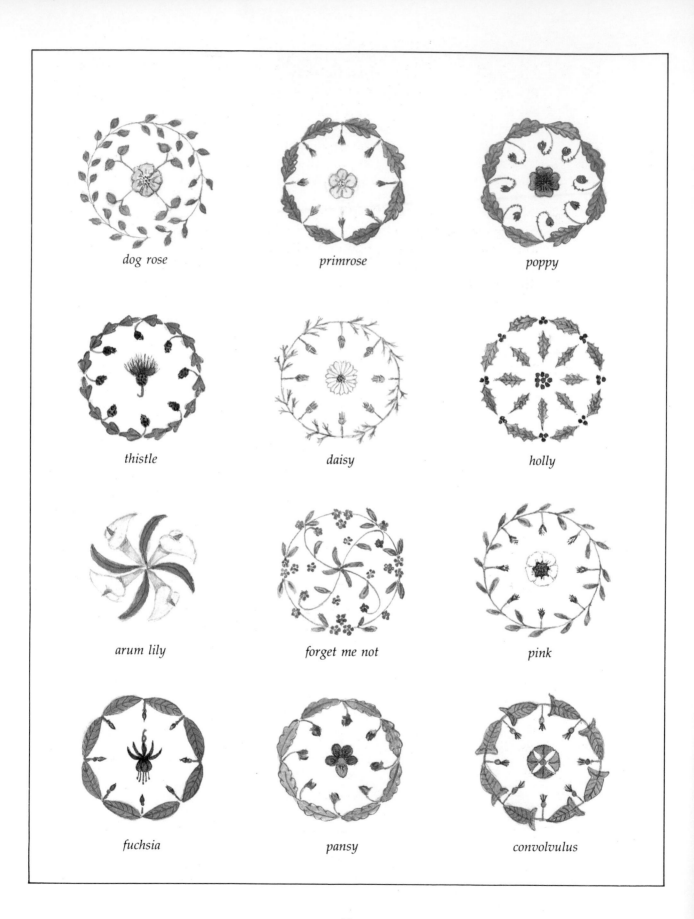

dog rose

primrose

poppy

thistle

daisy

holly

arum lily

forget me not

pink

fuchsia

pansy

convolvulus

Semi-stylised floral border

Circles are used again here, to create this filigree watercolour design, which is highlighted with dots of shell gold. The same theme can be applied in other ways by choosing different flowers and corner designs.

Below I show an alternative design, which uses the same range of colours.

Circular corner designs

On my country walks to the local village shops, I love studying the flowers and plants that adorn the Norfolk hedgerows. The twelve stylised corner designs ,opposite, are based on flowers I see on my walks, and also on the plants that grow in my garden.

When working on these designs back on my drawing board, I use a compass to make a template and draw out the design, accurately measuring the points that form the basis of the pattern.

Mixed bouquet

Here I combine stylised corner sections with a natural
border and base the pattern on a series of different sized
circles. I use watercolours for the flowers, leaves and
grasses, and when the colours are dry I add the corner
sections, using a mapping pen and red ink.

Banners, ribbons and rope work.

Festive border

Bows and garlands adorn this pretty delicately coloured leaf design. Acorns and oak leaves decorate the lower edge. This border could look over-fussy, but I have kept the choice of colours to a minimum and spread them around the border to create a sense of rhythm and harmony.

I use watercolours on the flowers and ribbons at the top of the design and on the oak leaf pattern on the lower edge. Gouache is used on the stylised purple and brown leaf pattern.

Simple exercises

Ribbons, banners and rope can be adapted in many ways to form unusual and pretty designs. Used as a single theme, or combined with flowers, leaves and other ideas, they can be entwined around simple messages and quotes with ease.

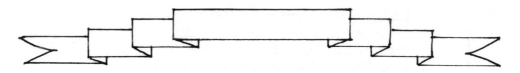

Try this simple exercise. Cut out a piece of stiff paper and fold it, as above, then open it out. This will give you an idea of how light and shade fall on to the folds, giving the impression of a piece of ribbon, or a banner. Practice drawing it on to a rough layout, or copy the design above.

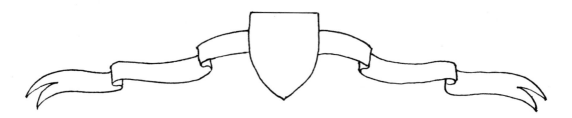

The same design can be used with an inset coat of arms to head a formal document.

Or it could be used for a more elaborate design. Try these exercises using different colours. Experiment with simple quotations and build up your own headings and borders.

Ribbon borders

Lovely borders can be created with simple ribbon designs and a limited palette. Here I show two different borders. This top design would be ideal as an invitation card, with a name dropped into the centre of the banner and the bottom design could be used on a greetings card for a friend or relative. I use gouache on the blue border lines and watercolours on the ribbons, tiny leaves and flowers.

Briony

Of all the gifts that a wise
providence grants us to make
life full and happy
friendship is
the most beautiful

Epicurus

Pansies and ribbons

Ribbons and flowers can be used to create lovely informal
designs which are suitable for greetings cards or party
invitations. I use watercolours for the flowers, applying
the colours in sequence. When dry, I highlight the flower
heads here and there with light strokes of white gouache.
When the corner sections are dry, I paint in the bows and
ribbons, using gouache.

Beauty and perfection
change and are
transformed continually.
Only what is simple and
natural defies change.

G. SEGANTINI

Anemones and ribbons

The same design can take on a different look by simply
changing the flowers and the colours. Here I use the same
colours as the design on the opposite page, but in a
different sequence. These borders are easily shortened or
lengthened as desired.

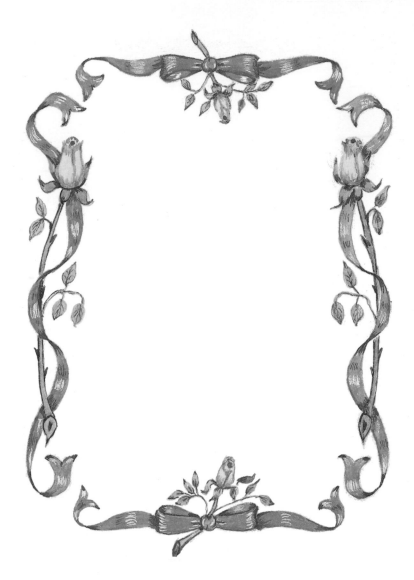

Ribbons and roses

In this design the emphasis is on the border edges instead of the corner sections. A balanced and harmonious design is created using single yellow roses entwined with ribbons and bows. The pattern can be extended by simply repeating the single rose design on each side.

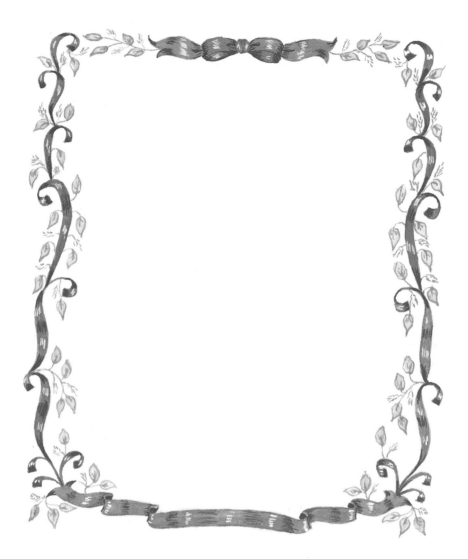

Ribbons and leaves

Leaves and tiny randomly-applied grasses decorate this ribbon border. The grasses and details on the leaves are drawn in with a mapping pen and a darker shade of the leaf colour. Shadows and highlights are added to the ribbons and bows using tiny brush strokes.

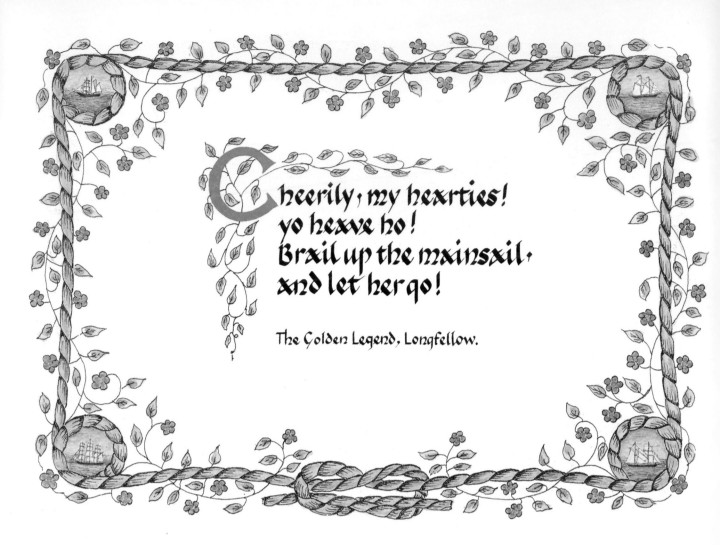

Cheerily, my hearties!
yo heave ho!
Brail up the mainsail,
and let her go!

The Golden Legend, Longfellow.

Rope border

When away on long sea journeys, sailors would
frequently while away the hours and days painting,
embroidering or learning other skills and handicrafts.
Using their limited surroundings as inspiration, they often
featured ropes and knots in their pictures and designs.

Four miniature paintings decorate the corners of this
design. Each picture shows a different sailing ship. The
circles are made using a coin or a circular template.

Using watercolours, I work on the rope border first and
ink in shadows and outlines when the paint is dry, with
a technical pen. The flowers are painted in next and the
stems and outlines inked in to complete the outer edges.

Finally, I paint the miniatures at each corner and fill in
the tiny details on the masts with a mapping pen. If you
prefer simple designs could be used instead on each of the
corners.

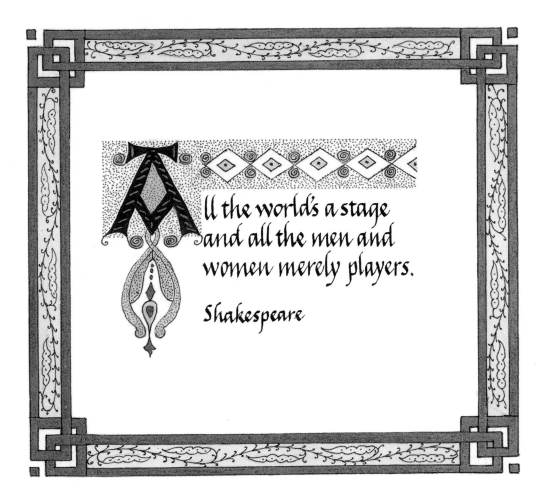

All the world's a stage and all the men and women merely players.

Shakespeare

Celtic border

This gold-edged border has a Celtic flavour and is a
stylised rope design with the four corners intertwining to
form an interlocking pattern. Once the text has been
written, I decorate the initial letter using watercolours and
a technical pen. I lay a pale wash around the border, wait
for it to dry and then ink in the pattern around the edges.
Finally, I apply gold leaf to the initial letter and the border.

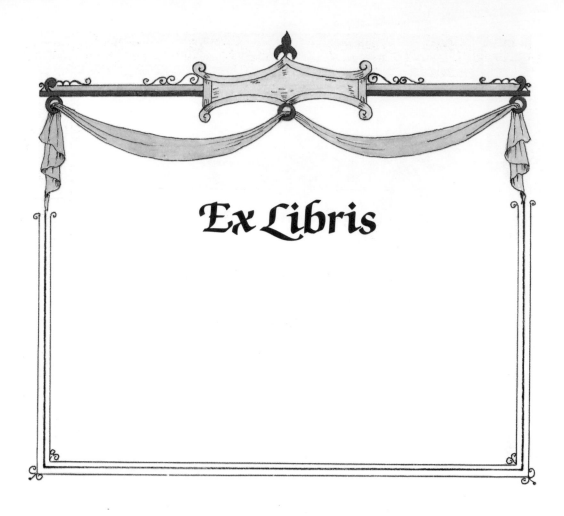

Ex Libris

Book plate

The above border is one I would choose to use as a book plate. The design is simple, with an elegant 'shield' set into the top centre. I use two pale watercolour washes, allowing them to dry before carefully inking in the design with a technical pen.

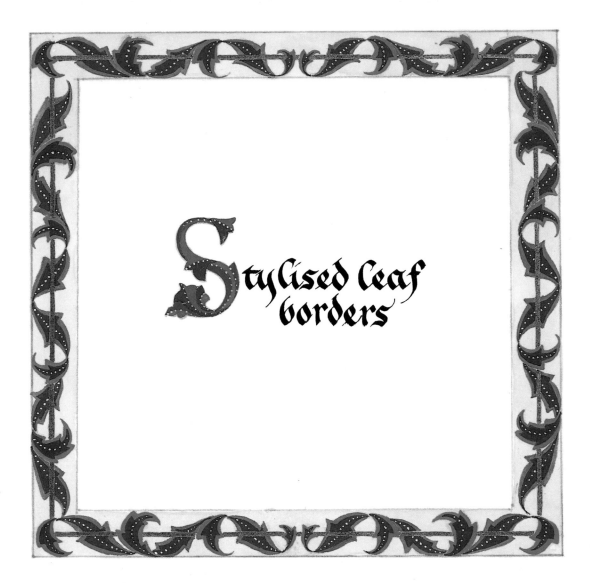

Stylised leaves

In this section I show how to use stylised leaves in a variety of ways to create beautiful borders.

Using gouache, I lay down a pale wash around the enclosed area of the above border. I pencil in the pattern when the paint is dry, then paint in the leaves, highlighting them with white dots. The gold leaf is added once all the colours are dry.

Interwoven designs

A variety of patterns can be created using brightly coloured stylised leaves. Here I use gouache and I show how designs can be formed around straight lines, the natural curves of the leaves acting as a contrast to the more severe central themes.

c. Here the colours are highlighted with tiny white dots. When the colours are dry, I draw in the straight lines and central dots using a mapping pen and red and blue paints.

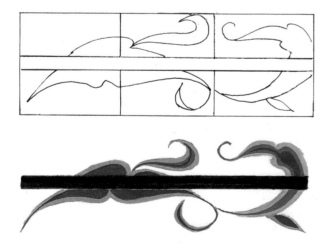

a. This design falls above and below the line. I paint in the colours first, then ink in the border using a technical pen.

b. A thick black line adds a three dimensional feel to a border. Here I paint the design beneath the central line first. When the colours are dry, I paint in the black border.

Corner designs

On these more complicated corner designs I divide the right angle and design my pattern on one side of the 45° angle. By reversing the traced image, the design can be exactly repeated on the other side. If you hold a mirror along the dividing line, you can see the repeat pattern, and alter it if you are not pleased with the design.

Normally I would use watercolours when working on dainty designs, but I prefer using gouache on these stylised leaf patterns.

Corner sections can be joined by simply painting or drawing in a straight edge on all sides. Tiny circles decorate the outer border. These are drawn in with a mapping pen and blue paint when all the colours are dry. The two different corner designs inside the border show how flowers, stems and tendrils can enhance a stylised leaf pattern.

Outlined corner designs

Here, as on the previous page, I show a corner design linked with a straight line, but I extend the pattern a little further by simply adding an outline in black ink. This gives a more ornate look to the border. The outlines are added when the colours are dry.

Gold leaf border

Tendrils of the palest blue are added to the brightly coloured leaves to soften the design. When the colours are dry, I highlight the border with tiny dots of shell gold.

Butterfly border

I use diamond-shaped butterfly motifs to complement the stylised leaf design in this border, which is highlighted with dots of shell gold.

Gouache is used on the leaf pattern and as usual I limit my palette to a few colours in order to create a sense of rhythm and harmony. Once the leaf design is dry, I carefully paint in the diamonds and butterflies using watercolours. The delicate markings are made with a mapping pen and paints. When the colours are dry, the final stage is the application of the shell gold.

Leaf and flower border

Stylised leaves can be used to create simple borders, or they can form part of a more elaborate design. Here, I include ornate flower heads and twisting stems in the pattern and highlight the whole design with areas of gold leaf. As with the rest of this section, I use gouache and apply the colours around the border in sequence. When the border is dry, I apply the gold leaf.

Frontispiece

I was inspired to create this border by the lovely frontispieces that adorn 12th, 13th and 14th century manuscripts. The four 'scribes' that decorate each corner are all members of my family – my younger son (top left); elder son (top right); grandson (bottom left) and husband (bottom right). Willow herbs and forget-me-nots are trained round the gold-edged medallions which are linked together with a gold 'rope', and all the medallions have an inset gold leaf pattern illustrating some of the materials that are used by scribes and illuminators: a palette and paintbrushes; a set square, quill and paintbrush; an open book, quill and pen. The stylised leaf pattern shown in this section decorates the four corners, contrasting with the delicate flowers and leaves around the border.

I do not cover the techniques of painting miniatures in this book, as this is a separate subject, but simple inset designs can be just as effective in an intricate border like this. Choose your design and work it out on your rough layout first.

When working on a border like the one opposite I apply the colour first, before laying on the gold leaf and inking in the stems, tendrils and design outlines. Here I use watercolours on the flowers. When the colours are dry, I work on the four corner designs. Still using watercolours, I paint in the figures. Normally, when painting miniatures on vellum, I use a stippling technique – tiny dots of colour are applied carefully and accurately. Here, however, as I have chosen to use a watercolour paper, I lay down slightly broader washes. When the figures are dry, I paint in the background with gouache leaving the pattern free for the application of gold leaf. I then soften the hairlines by painting over the hair with a second layer of watercolour.

Once the four corner designs are complete, using gouache I paint in the backgrounds of the medallions, applying the colour around the gold leaf pattern.

Now I am ready to start gilding the design. Once the gold leaf has been applied, I ink in all the outlines, stems and tendrils with a technical pen and black ink. To sharpen up small leaf designs, I sometimes outline the pattern with black ink, as I show here, but I would not do this with larger designs.

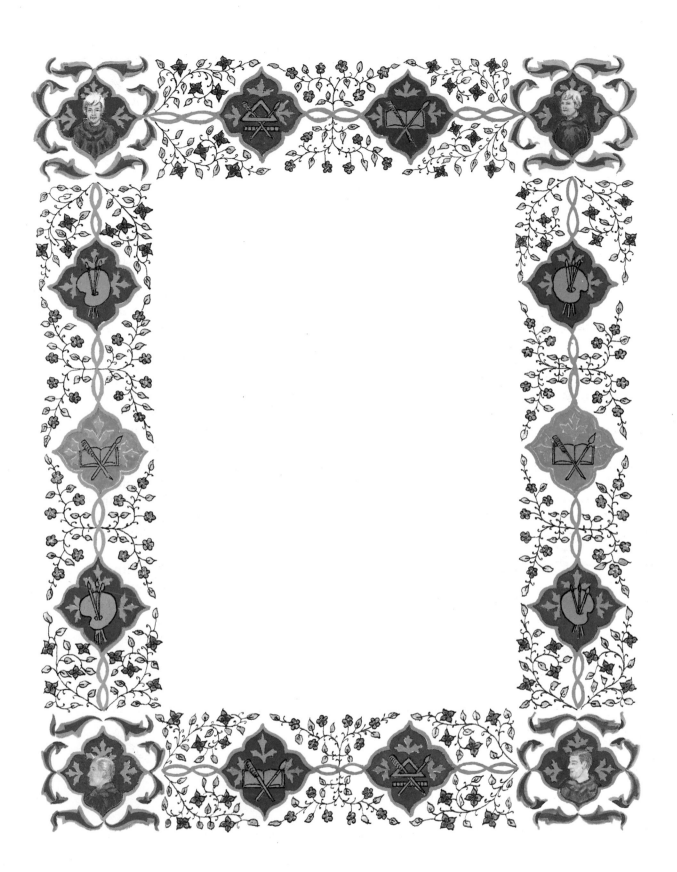

The end